To Sarah -

Thank you for the best on my Planet!

wonderful

Lora Drasner :)

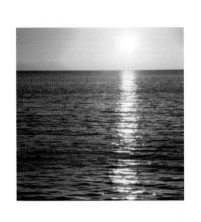

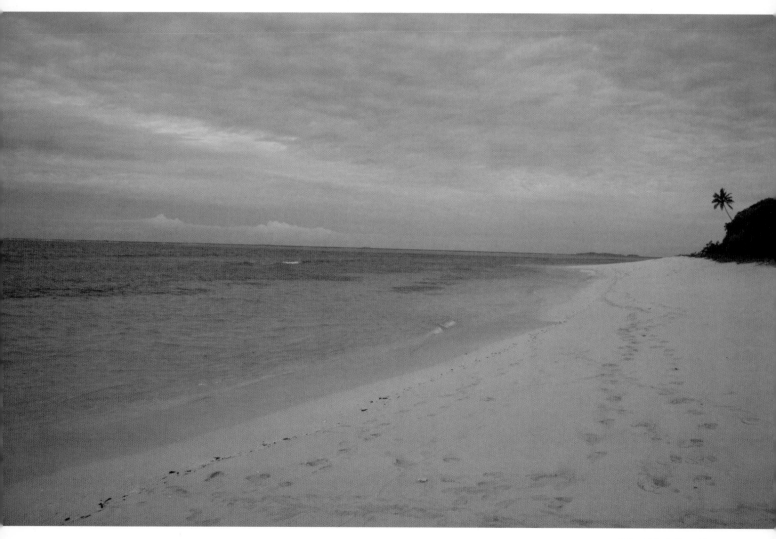

Ha'apai Island Group, Tonga

Sunsets

by Lora Drasner

COURAGE
BOOKS

AN IMPRINT OF RUNNING PRESS
PHILADELPHIA • LONDON

For my lovely Mother,
And a heartfelt thank you to my husband
for making my dreams come true.

© 2008 by Lora Drasner
All rights reserved under the Pan-American and International Copyright
Conventions
Printed in China

This book may not be reproduced in whole or in part, in any form or
by any means, electronic or mechanical, including photocopying, recording,
or by any information storage and retrieval system now known
or hereafter invented, without written permission from the publisher.

9 8 7 6 5 4 3 2 1
Digit on the right indicates the number of this printing

Library of Congress Control Number: 2007928504

ISBN: 978-0-7624-3253-0

Cover photo and interior photos by Lora Drasner
Cover and interior design by Corinda Cook
Introduction and quote collection by Lora Drasner
Edited by Jennifer Colella and Kristen Green Wiewora
Typography: Caslon, Dorchester, Goudy, and Univers

This book may be ordered by mail from the publisher.
But try your bookstore first!

Published by Courage Books, an imprint of
Running Press Book Publishers
2300 Chestnut Street
Philadelphia, PA 19103-4371

Visit us on the web!
www.runningpress.com

Photograph on page 1: San Blas Islands

Contents

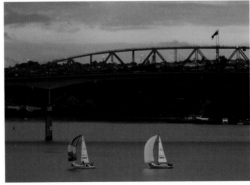

Auckland Harbor, New Zealand

Introduction

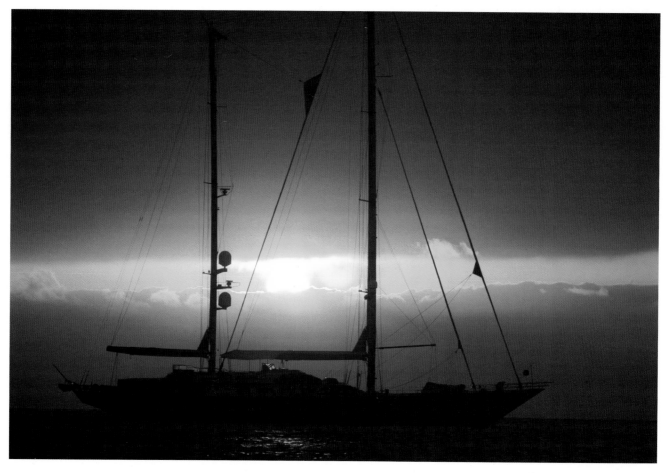

Andromeda la Dea in the Galapagos

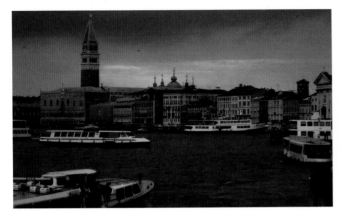

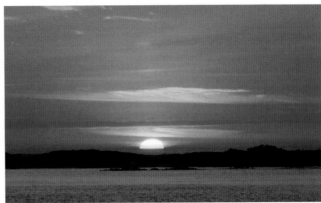

Venice, Italy

Santa Cruz, Galapagos

Jumby Bay, Antigua, Valentine's Day 1999, I noticed a mysterious yacht named *Destiny* anchored off the beach. Five years later the man on board became my husband, but the real fun began after our wedding in Venice, Italy, 2004. Previously cruising the Mediterranean, we decided to have a real adventure. We set out on an epic journey of circumnavigating the globe aboard our sailing yacht, *Andromeda la Dea*.

Having lived in New York City and having grown up in a small town in Washington State, I inherited wanderlust from my father. He was raised in Holland but left after the war to see the world. My father always said the Pacific Northwest is the most beautiful place on earth. I, of course, wanted to find out for myself.

My photographic journey began during an 11-day crossing of the Atlantic Ocean. We sailed from the Canary Islands to Antigua. I was inspired by the incredible sunsets in the mid-Atlantic. There was nothing else around for thousands of miles, just us and the ocean. I thought how lucky I was to have this rare experience. I also wanted to share the beauty with others.

While my father may be correct about the Pacific Northwest, I've experienced many fascinating places, and some of them are shared in these photographs.

Our journey isn't over yet, as there are many sunsets yet to be experienced, including Asia, Europe, and more of America. And your own journey sailing into the sunset is just beginning, so enjoy your adventure!

—*Lora Drasner*

Enlightenment

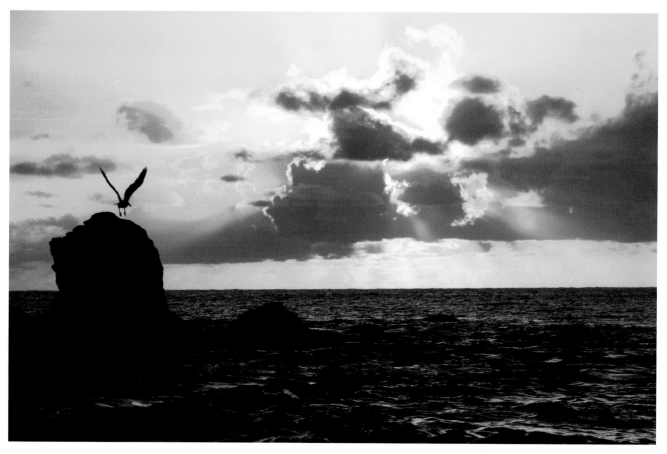

Guadalupe, Caribbean

Knowing others is wisdom, knowing yourself is enlightenment.

—Lao Tzu
Chinese Taoist Philosopher
c.6th century B.C.

A wise man will make more opportunities than he finds.

—Sir Francis Bacon
English philosopher and statesman
1561–1626

Think like a wise man but express yourself like the common people.

—*W. B. Yeats*
Irish poet and dramatist
1865–1939

Fiji

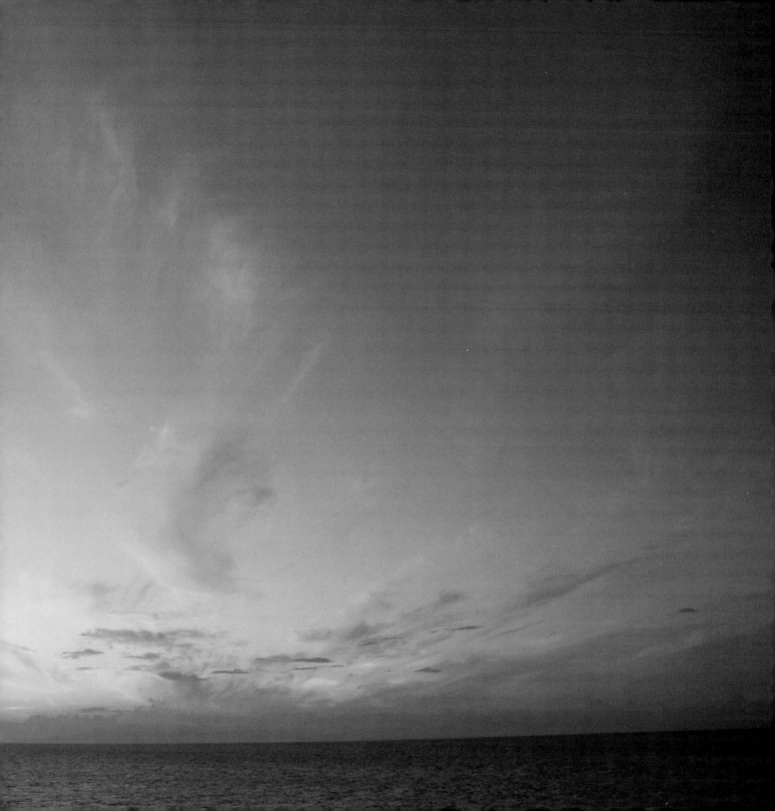

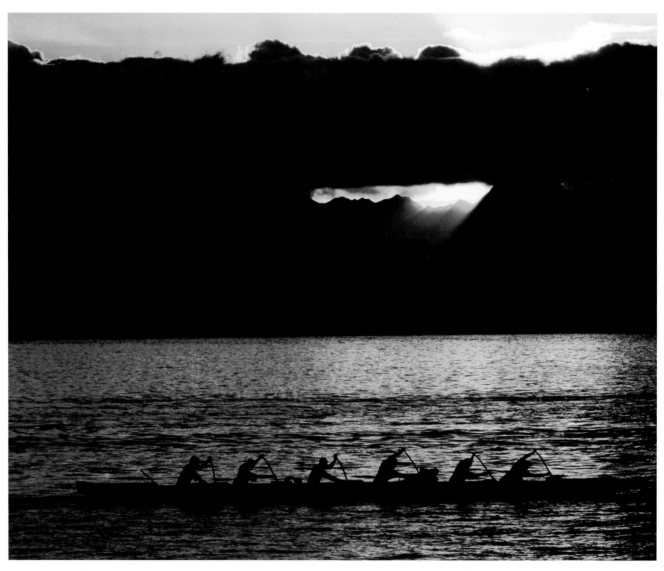

Moorea, Tahiti

Genius is 1% inspiration, 99% perspiration.

—Thomas Edison
American inventor
1847–1931

You can discover more about a person in an hour of play than in a year of conversation.

—*Plato*
Greek philosopher
c.428–348 B.C.

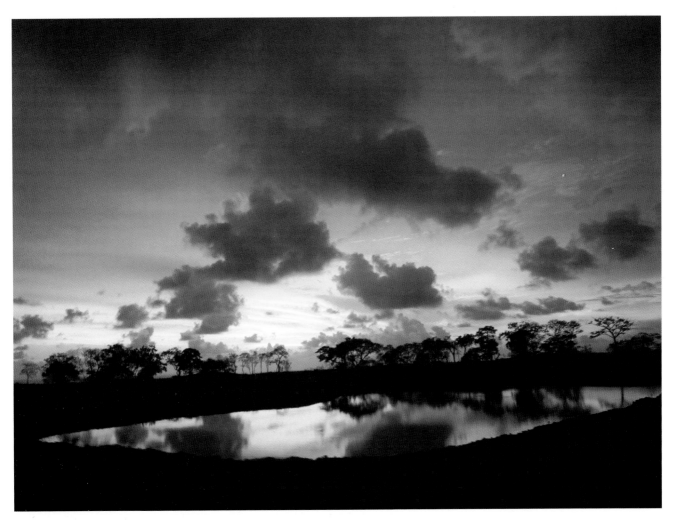

Guanacaste, Costa Rica

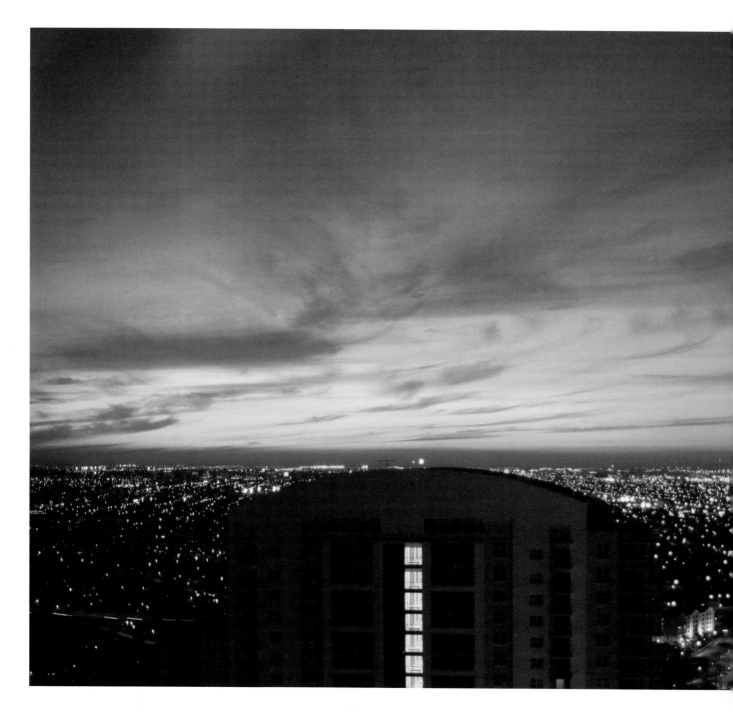

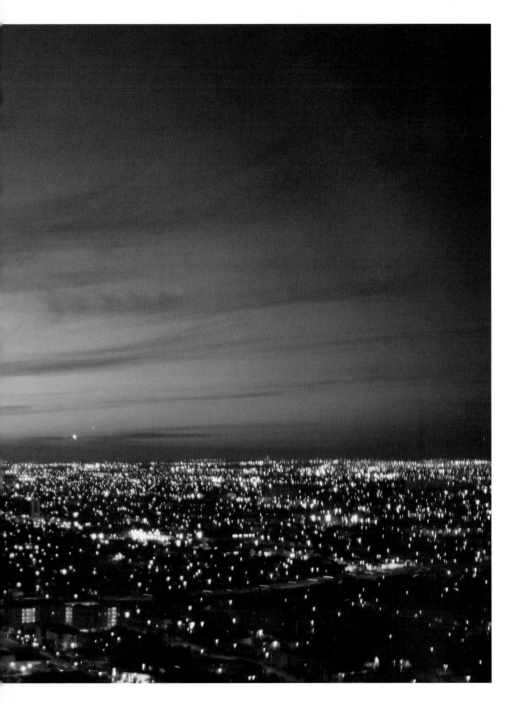

All that we are

is the result of what

we have thought.

The mind is everything.

What we think,

we become.

—*Buddha*

Miami, Florida

Wisdom begins in wonder.

—Socrates
Greek philosopher
c.470–399 B.C.

Dravuni, Fiji

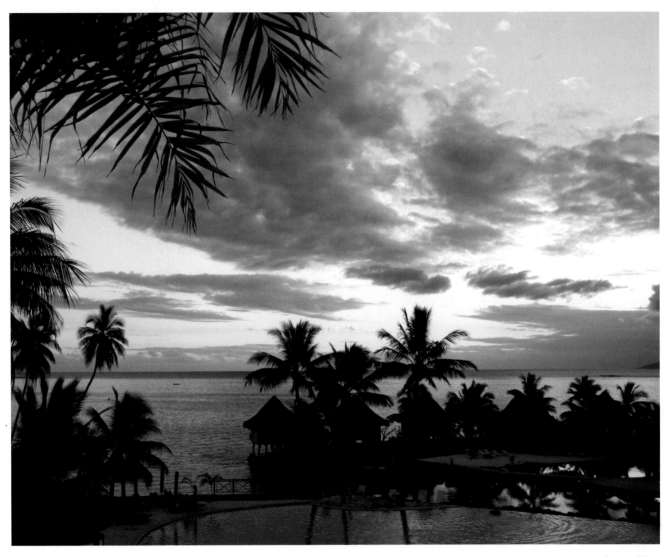

Papeete, Tahiti

Be kind to all; judge no one; learn from all; say thank you.

—BUDDHIST SAYING

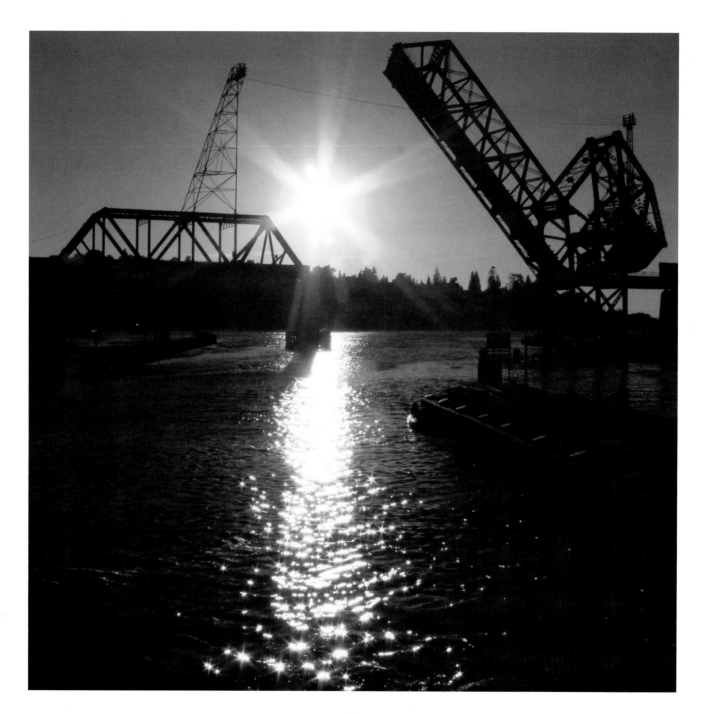

You are not here merely to make a living.

You are here to enable the world to live more amply,

with greater vision, and with a finer spirit of hope and

achievement. You are here to enrich the world.

—Woodrow Wilson
28th President
1856–1924

I HAVE STRIVEN NOT TO LAUGH AT HUMAN ACTIONS,

NOT TO WEEP AT THEM, NOR TO HATE THEM,

BUT TO UNDERSTAND THEM.

—*Baruch Spinoza*
Dutch philosopher
1632–1677

Ballard Locks, Washington

We make a living by what we get;
we make a life by what we give.

—Sir Winston Churchill
British Prime Minister
1874–1965

Wise sayings often
fall on barren ground,
but a kind word
is never thrown away.

—Sir Arthur Helps
English writer
1813–1875

The greater danger for most men lies in not setting our aim too high and falling short, but in setting our aim too low and achieving your mark.

—*Michelangelo*
Italian artist
1475–1564

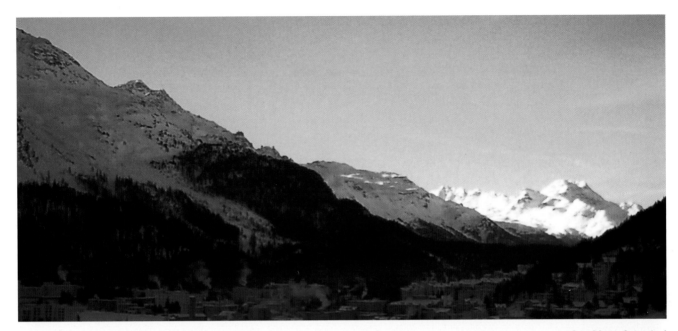

Saint Moritz, Switzerland

Miami, Florida

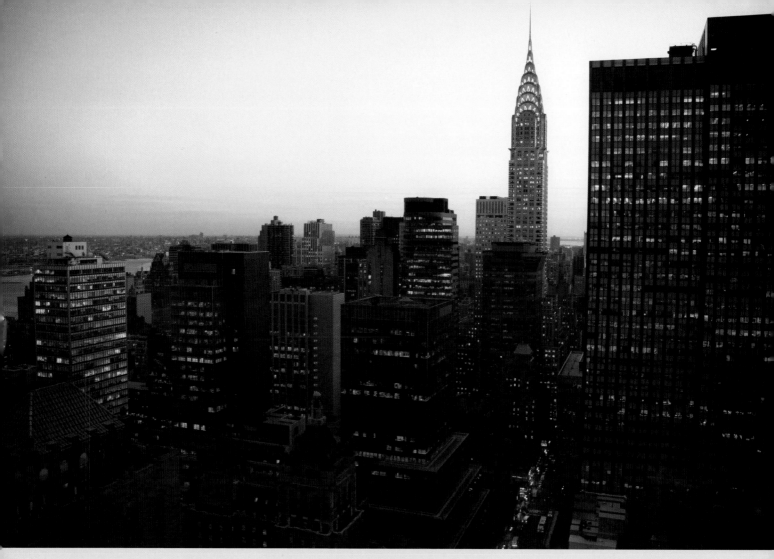

Chrysler Building, New York

Fortune does not change men, it unmasks them.

—Suzanne Necker
1739–1794
Wife to French Statesman

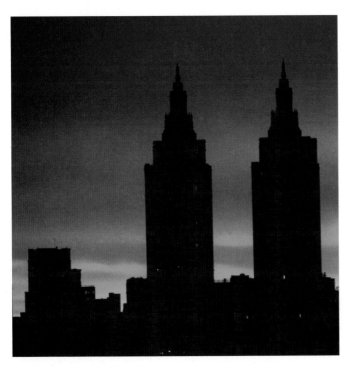

New York, New York

IT IS NOT
ENOUGH TO HAVE
A GOOD MIND.
THE MAIN
THING IS TO USE
IT WELL.

—*Descartes*
French philosopher
1596–1650

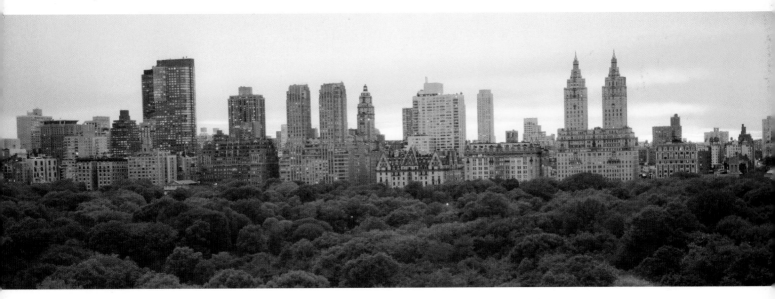

Central Park, New York

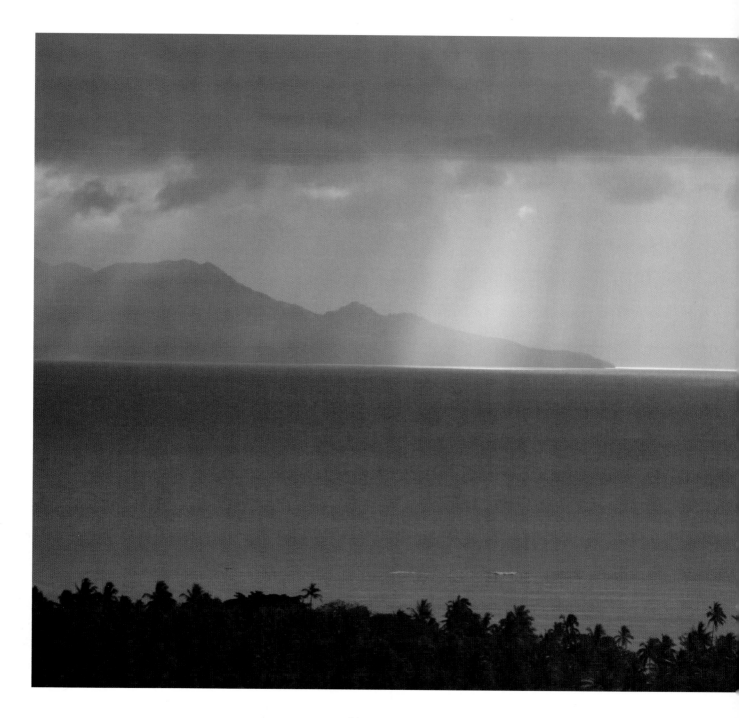

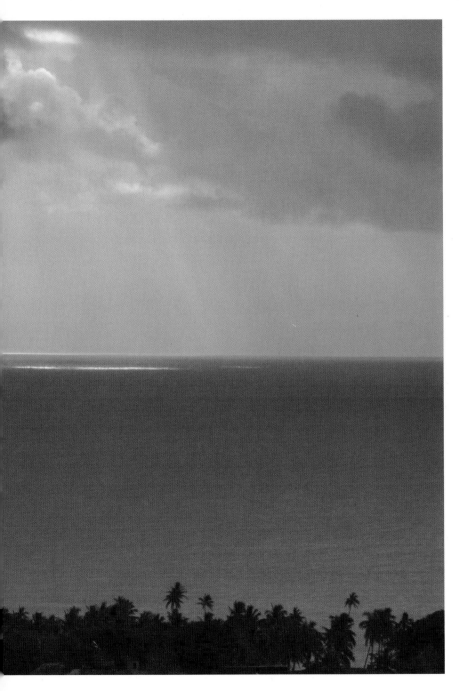

Great people
are those who
make others feel
that they too,
can become great.

—Mark Twain
American writer
1835–1910

Wakaya Island, Fiji

Nature

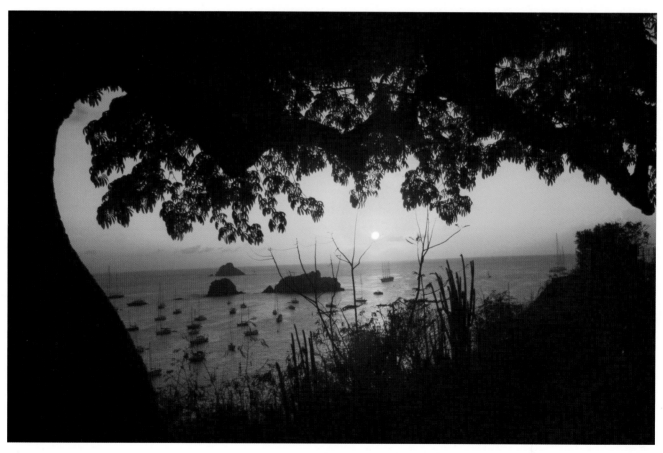

Saint Barths

In all things of nature there is something of the marvelous.

—Aristotle
Greek philosopher
384–322 B.C.

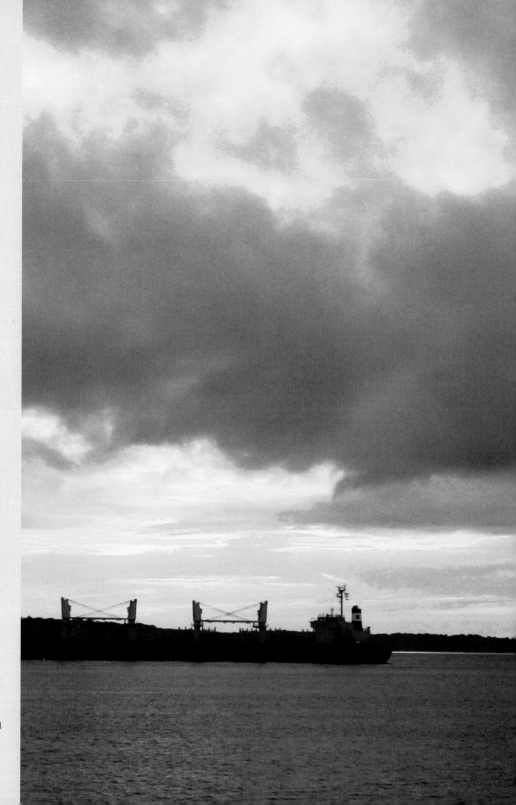

Fernandia, Galapagos

The glorious gifts of
the Gods are not to
be cast aside.

—Homer
Greek poet
c. 700 B.C.

Panama Canal

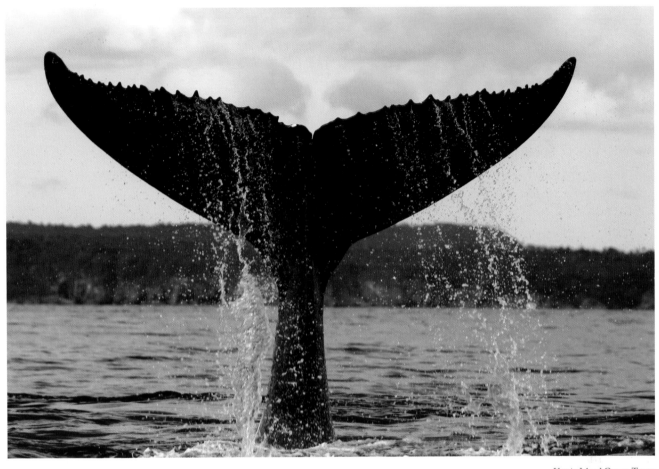

Vava'u Island Group, Tonga

. . . MOST OF OUR ENERGY GOES INTO UPHOLDING OUR IMPORTANCE. IF WE WERE CAPABLE OF LOSING

SOME OF THAT IMPORTANCE, TWO EXTRAORDINARY THINGS WOULD HAPPEN TO US. ONE, WE WOULD FREE

OUR ENERGY FROM TRYING TO MAINTAIN THE ILLUSORY IDEA OF OUR GRANDEUR; AND TWO, WE WOULD PRO-

VIDE OURSELVES WITH ENOUGH ENERGY TO CATCH A GLIMPSE OF THE ACTUAL GRANDEUR OF THE UNIVERSE.

—Carlos Castaneda
Peru-born American writer
1931–1998

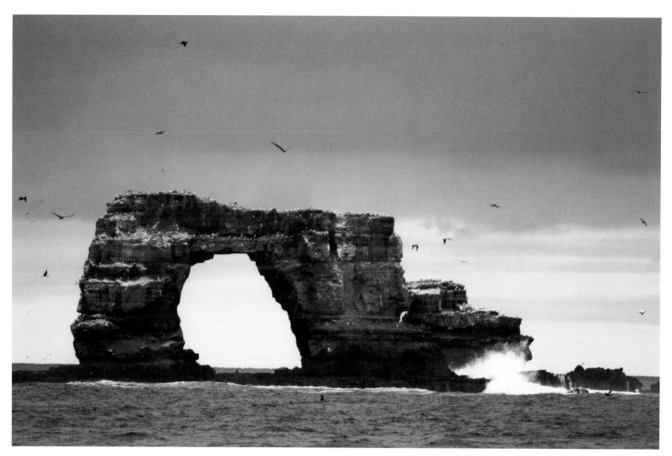

Darwin's Arch, Galapagos

There is grandeur in this view of life.

—CHARLES DARWIN
ENGLISH NATURALIST
1809–1882

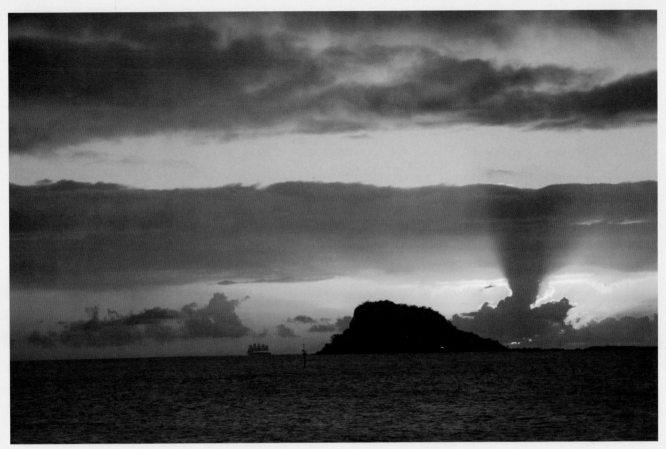

Tobago Cays, Caribbean

The highest possible stage in moral culture is when we recognize that we ought to control our thought.

—Charles Darwin
English naturalist
1809–1882

Bel Air, California

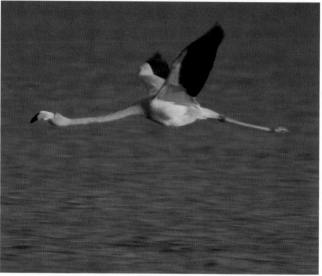

Floreana, Galapagos

Nature's intelligence functions with effortless ease . . . with carefreeness, harmony, and love.

—*Deepak Chopra*
Indian medical doctor
b. 1946

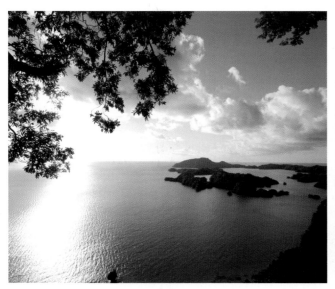

Taveuni, Fiji Bangall, New York

Observe due measure, for right timing in all
things is the most important factor.

—Hesiod
Greek poet,
c.700 B.C.

33

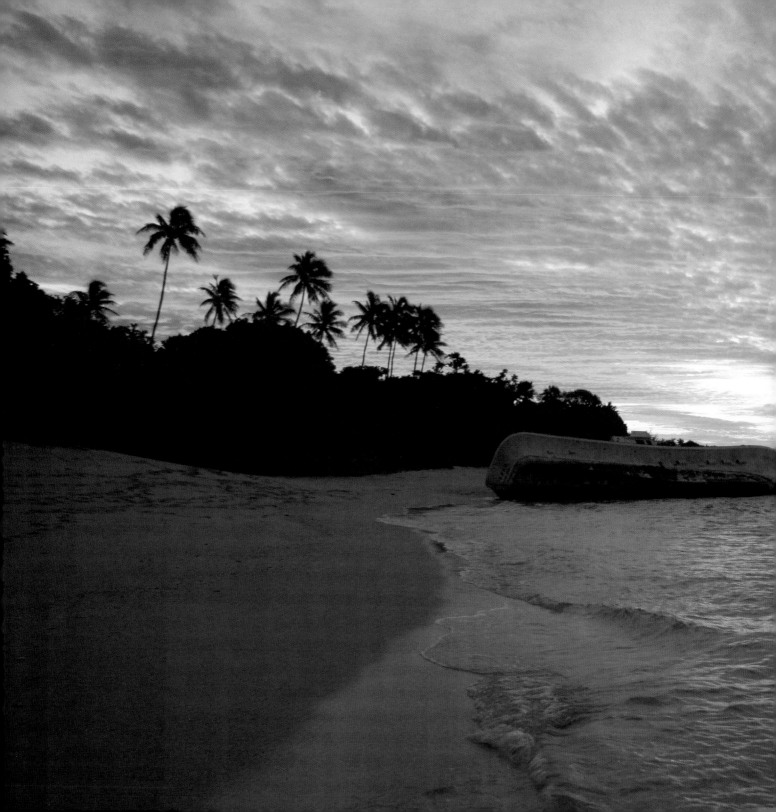

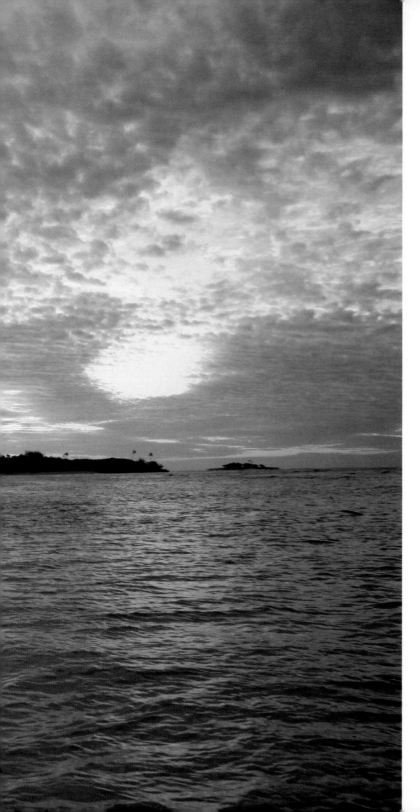

I invent nothing;
I rediscover.

—Auguste Rodin
French sculptor
1840–1917

Nomuka Iki Island, Tonga

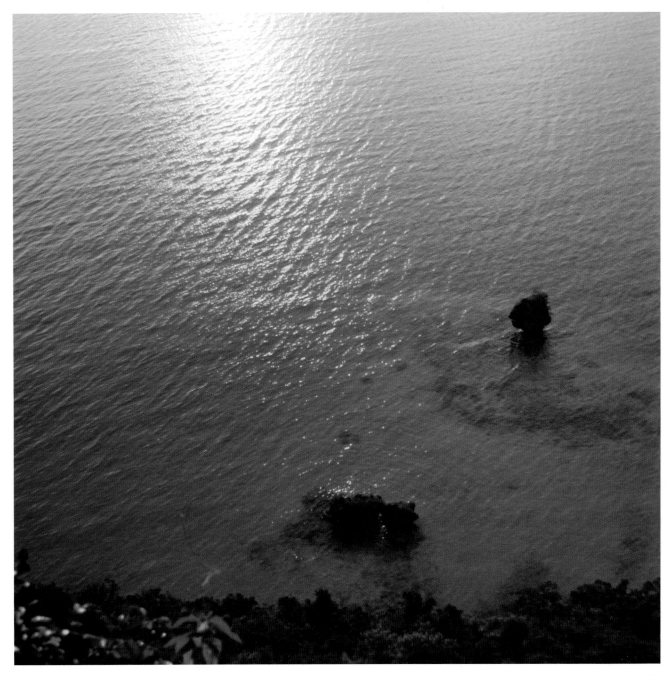

Lau Island Group, Fiji

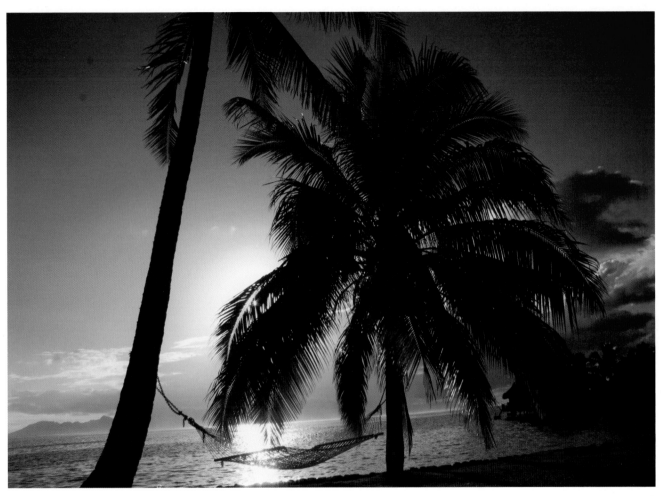

Tahiti

Far from idleness being the root of all evil,
it is rather the only true good.

—Soren Kierkegaar
Danish philosopher and theologian
1813–1855

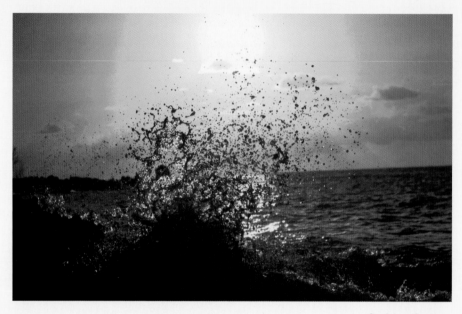

Guadalupe, Caribbean

The mystery of language was revealed to me. I knew then that "w-a-t-e-r" meant the wonderful cool something that was flowing over my hand. That living word awakened my soul, gave it light, joy, set it free.

—Helen Keller
Deaf and blind American activist
1880–1968

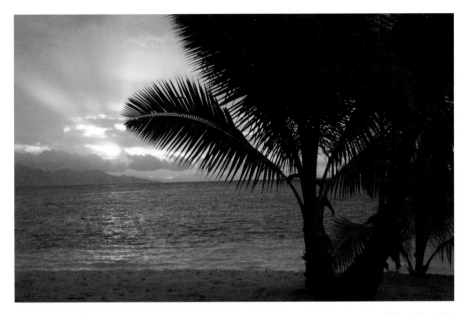

Wakaya Island, Fiji

We do not see nature with our eyes, but with our understandings and our hearts.

—William Hazlitt
English writer
1778–1830

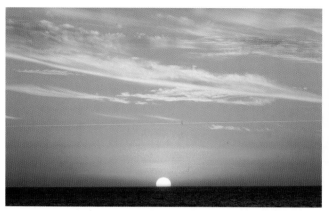

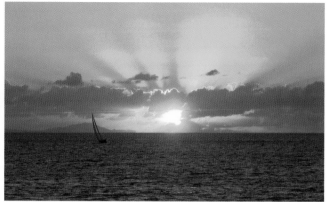

Fiji Antigua

HUMAN SUBTLETY . . . WILL NEVER DEVISE AN INVENTION MORE BEAU-
TIFUL, MORE SIMPLE OR MORE DIRECT THAN DOES NATURE, BECAUSE IN
HER INVENTION NOTHING IS LACKING, AND NOTHING IS SUPERFLUOUS.

—LEONARDO DA VINCI
ITALIAN ARTIST AND INVENTOR
1452–1519

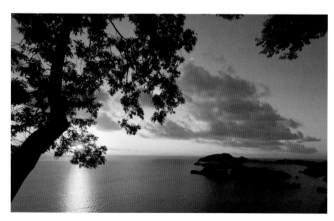

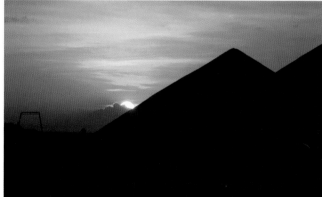

Fiji Bonaire, Netherlands Antilles

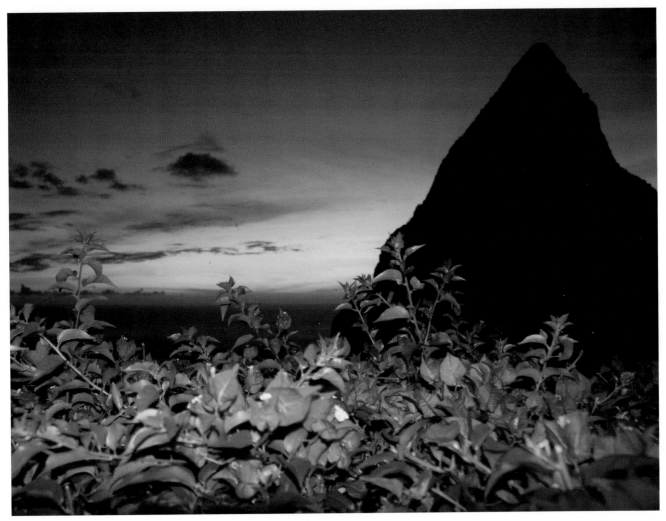

The Pitons, Saint Lucia

I think it pisses God off if you walk by the color purple in a field somewhere and don't notice it.

—Alice Walker
African-American writer
b. 1944

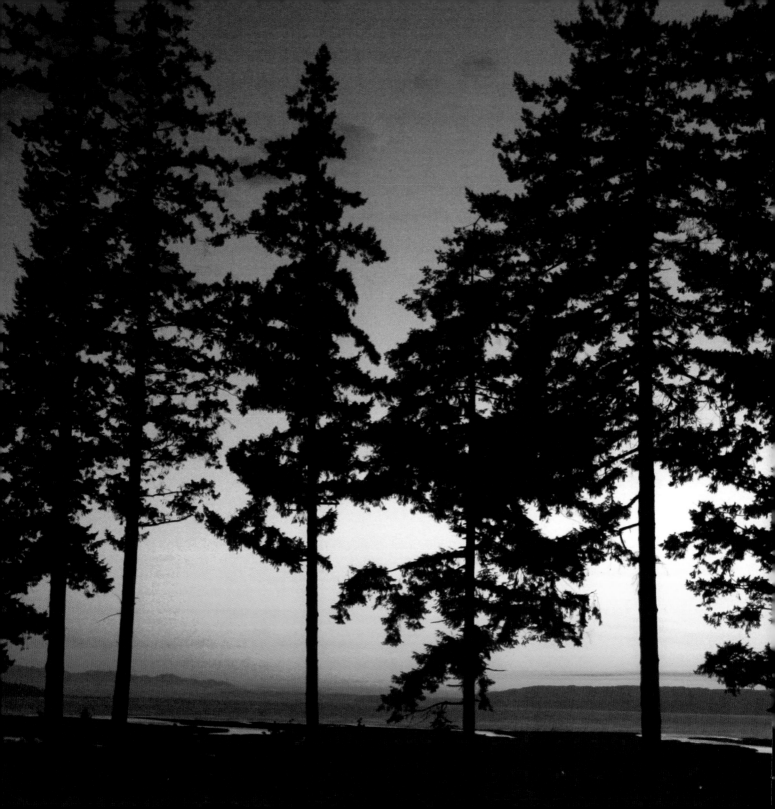

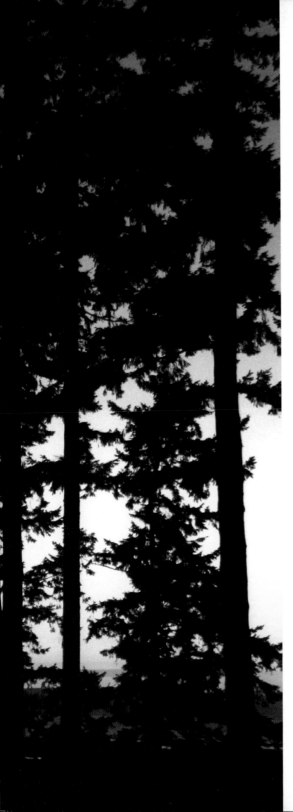

He plants trees to benefit another generation.

—Caecilius Statius
Roman playwright
220–168 B.C.

Skagit Valley, Washington

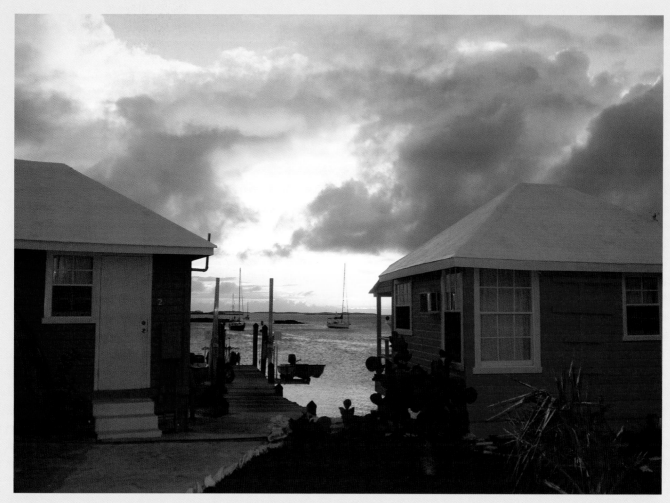

The idea that people living close to nature tend to be noble,
it's seeing all those sunsets that does it.

—*Daniel Quinn*
American writer
b. 1935

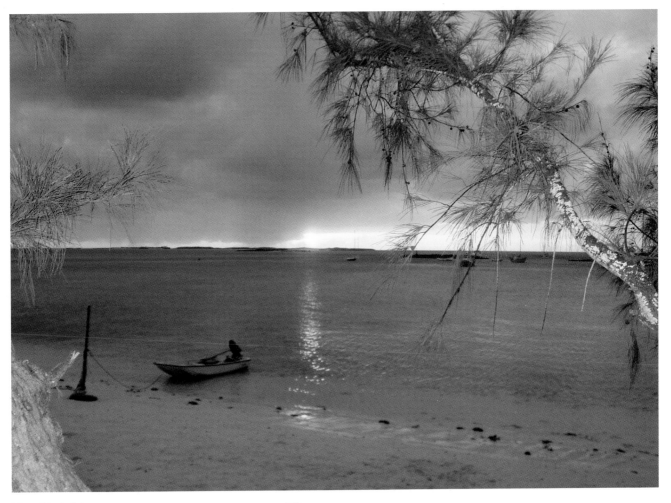

Exuma Islands, Bahamas

THE SUN WITH ALL THOSE PLANETS REVOLVING AROUND IT AND DEPENDENT ON IT, CAN STILL RIPEN A BUNCH OF GRAPES AS IF IT HAD NOTHING ELSE IN THE UNIVERSE TO DO.

—Galileo Galilei
Italian astronomer
1564-1642

Beauty

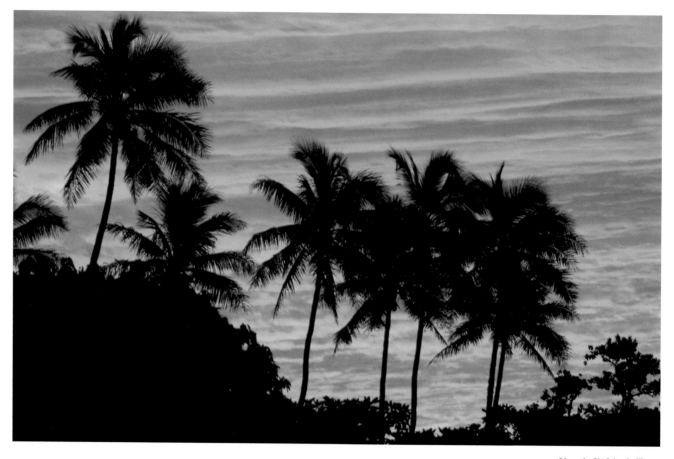

Nomuka Iki Islands, Tonga

THE ESSENCE OF ALL BEAUTIFUL ART, ALL GREAT ART, IS GRATITUDE.

—Friedrich Nietzsche
German philosopher
1844–1900

Think of all the beauty

left around you and be happy.

—Anne Frank
Jewish Holocaust writer
1929–1945

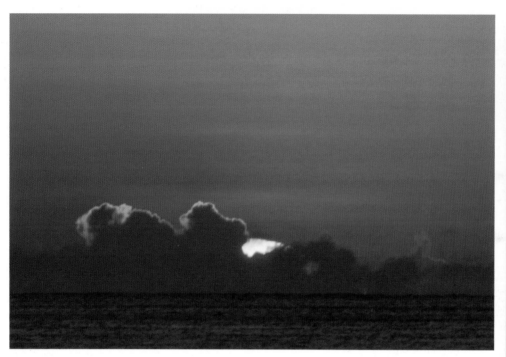

Fatu Hiva, Marquesas

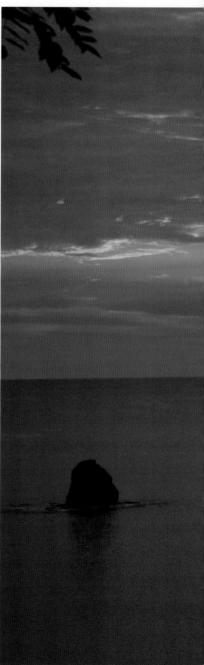

All the beautiful sentiments in the world weigh less than a single lovely action.

—*James Russell Lowell*
American writer
1819–1891

Monkey Head Rock, Costa Rica

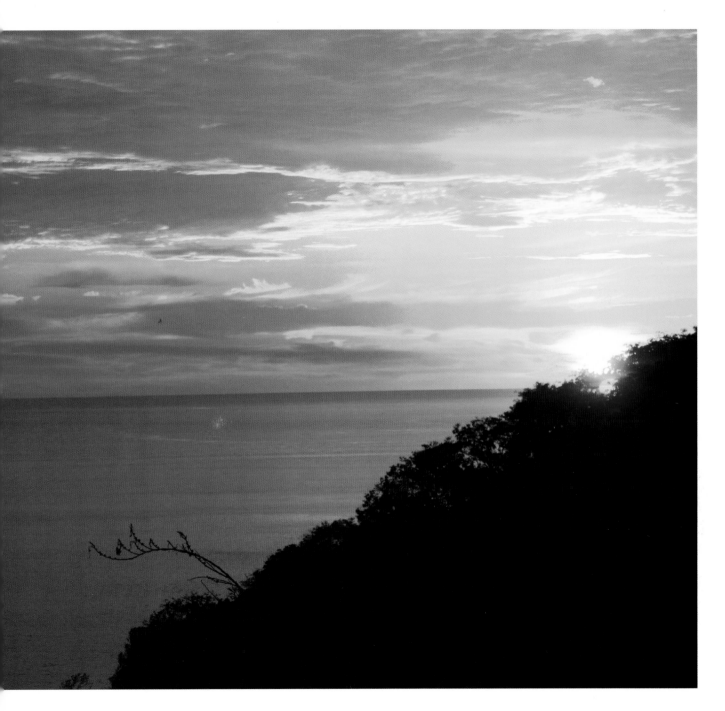

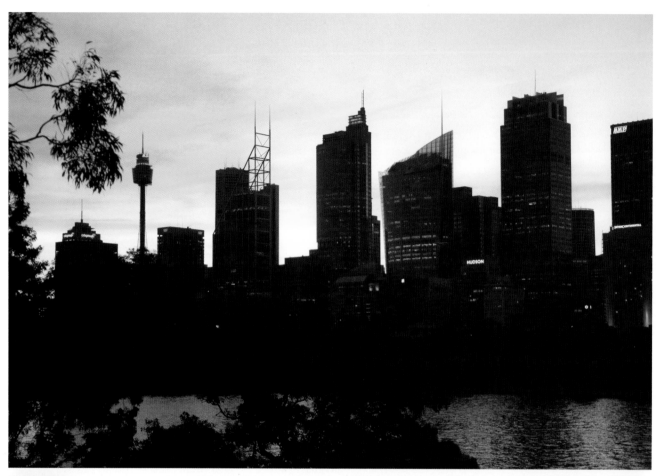

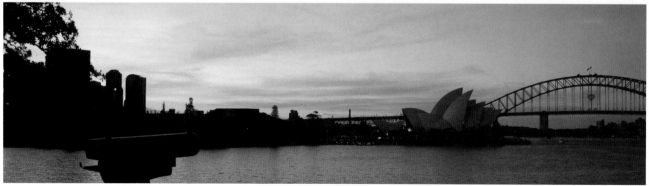

Sydney Harbor, Australia

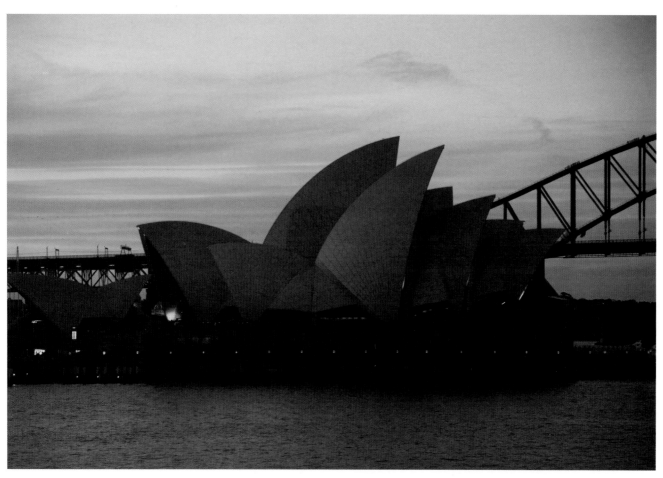

Sydney Opera House, Australia

The most **beautiful thing** we can experience is the mysterious. It is the source of all true **art and science.**

—Albert Einstein
American scientist
1879–1955

BEAUTY SEEN IS NEVER LOST . . .

—*John Greenleaf Whittier*
American Quaker poet
1807–1892

*A thing
of beauty is
a joy
forever.*

—John Keats
English poet
1795–1821

Marquesas

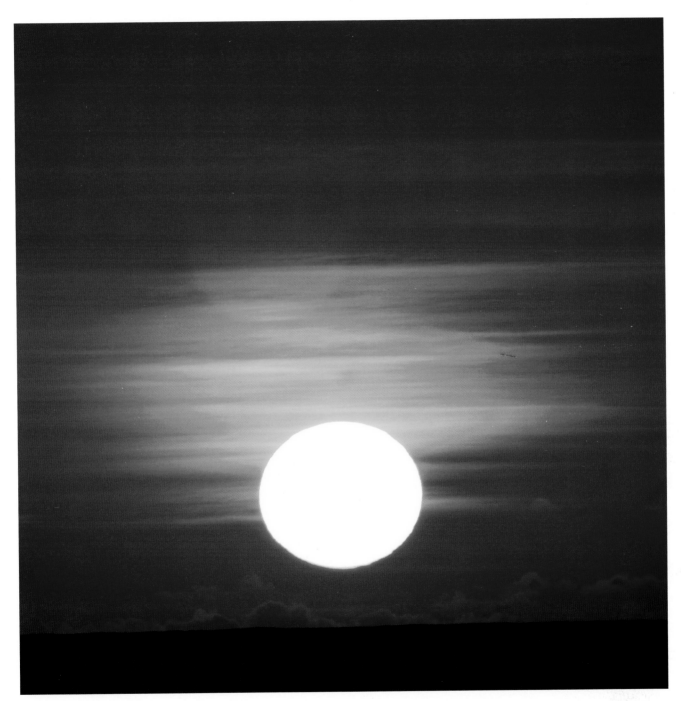

Illusion is the first of all pleasures.

—Oscar Wilde
Irish writer
1854–1900

Society Islands

Man's desires are limited by his perceptions;
none can desire what he has not perceived.

—*William Blake*
English poet
1757–1827

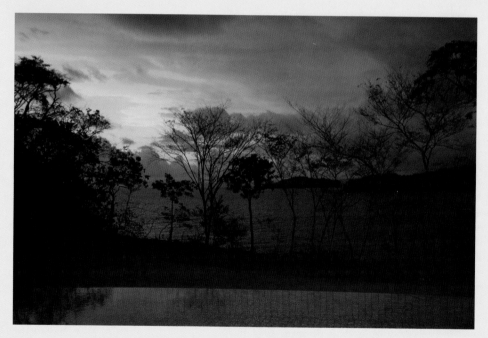

Peninsula Papagayo, Costa Rica

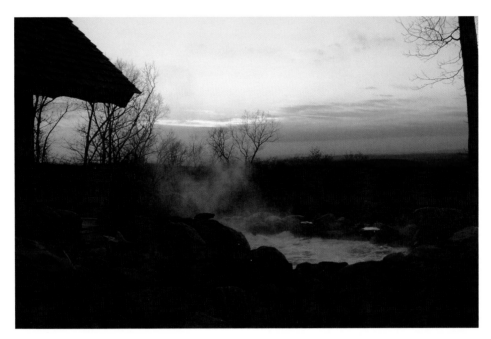

Dutchess County, New York

What I dream of is an art of balance, of purity and serenity . . . a soothing, calming influence on the mind.

—*Henri Matisse*
French artist
1869–1954

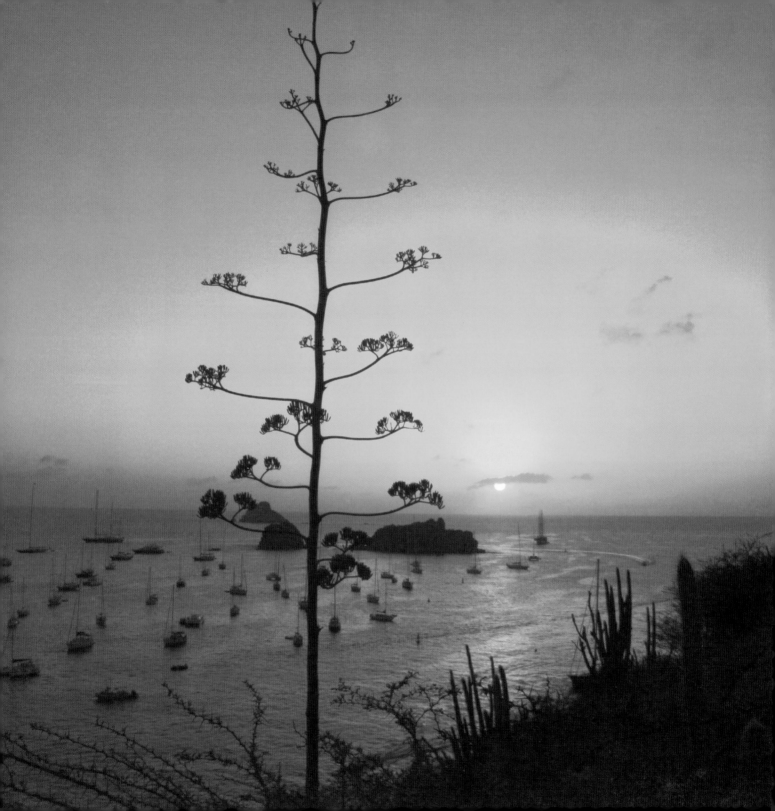

What is a weed? A plant whose virtues have not been discovered.

—Ralph Waldo Emerson
American essayist
1803–1882

French West Indies

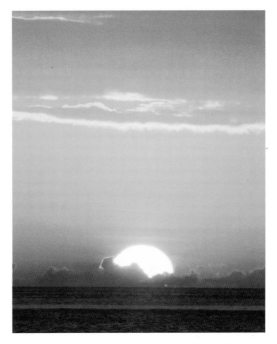

Bay of Virgins, Marquesas

Where observation is concerned, chance favors only the prepared mind.

—LOUIS PASTEUR
FRENCH CHEMIST
1822-1895

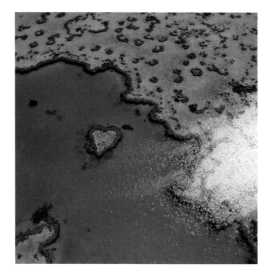

Great Barrier Reef, Australia

One filled with joy preaches
without preaching.

—*Mother Teresa*
Catholic humanitarian
1910–1997

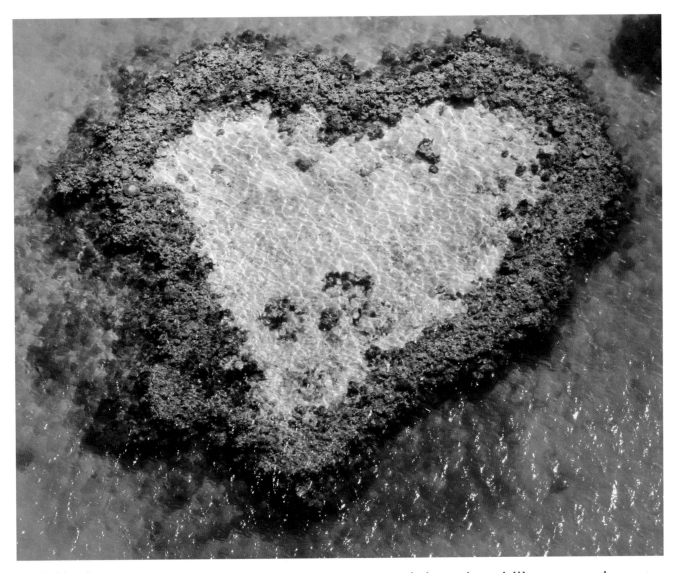

Heart Reef, Australia

Youth is happy because it has the ability to see beauty.
Anyone who keeps the ability to see beauty never grows old.

—Franz Kafka
Czechoslovakia-born German writer
1883–1924

Happiness

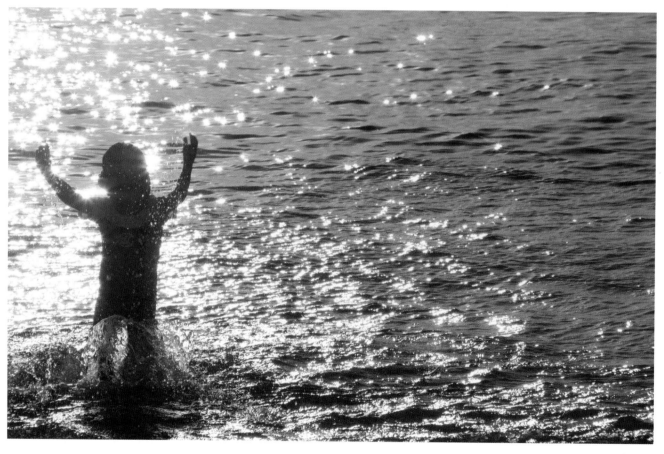

Australia

Happiness does not depend on outward things, but on the way we see them.

—Leo Tolstoy
Russian writer
1828–1910

If a little dreaming
is dangerous the cure
for it is not to dream
less but to dream more,
to dream all the time.

—Marcel Proust
French intellectual
1871–1922

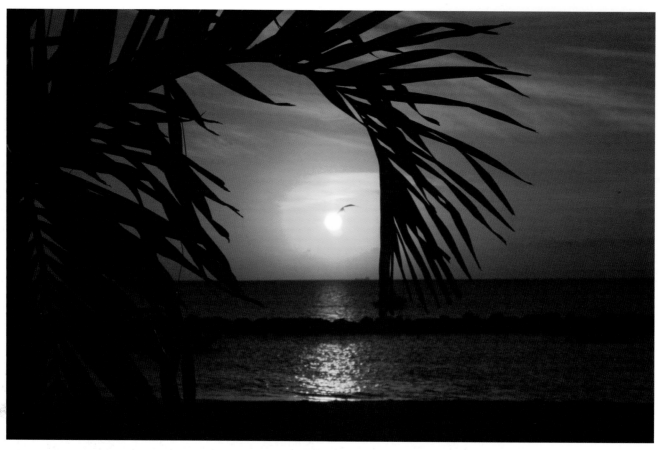

Nevis, Caribbean

As soon as you trust yourself,
you'll know how to live.

—Johann Wolfgang von Goethe
German writer
1749–1832

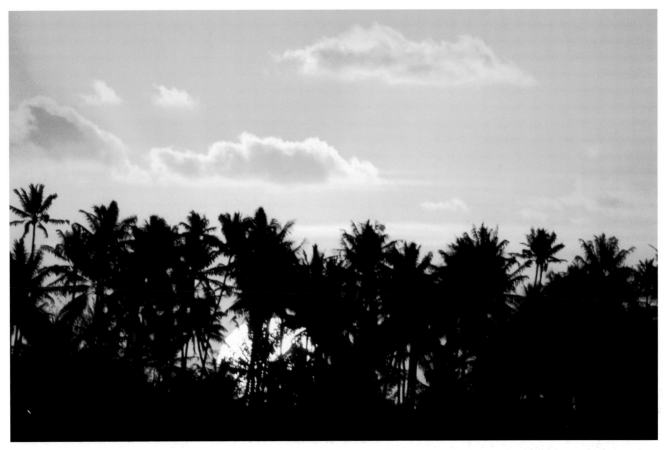

Bora Bora

FRIENDSHIP CONSISTS OF
FORGETTING WHAT ONE
GIVES AND REMEMBERING
WHAT ONE RECEIVES.

—Alexander Dumas
French writer
1802–1870

We must ask for world **happiness.**
World **peace** involves silence instead of smiles.

—Anonymous

Seattle, Washington

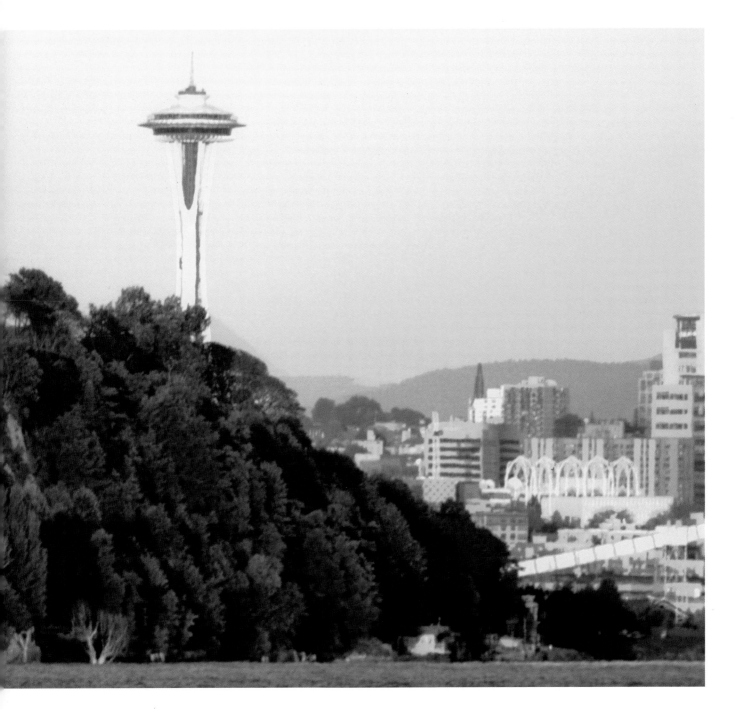

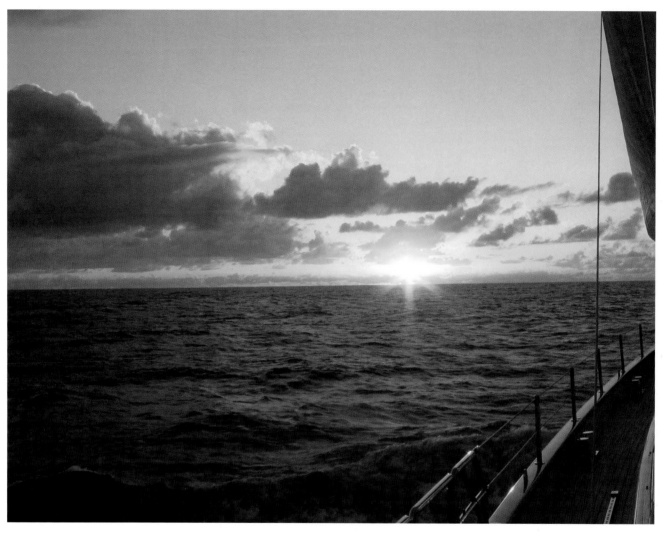

Pacific Ocean

THE GREATEST HAPPINESS OF LIFE IS THE CONVICTION THAT WE ARE LOVED—
LOVED FOR OURSELVES OR RATHER, LOVED IN SPITE OF OURSELVES.

—Victor Hugo
French writer
1802–1885

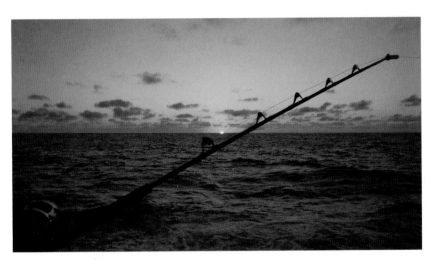

Costa Rica

God gave us
the gift of life;
it is up to us to
give ourselves
the gift
of living well.

—VOLTAIRE
FRENCH ENLIGHTENMENT WRITER
1694–1778

The most manifest sign of wisdom is continued cheerfulness.

—Michel de Montaigne
French essayist
1533–1592

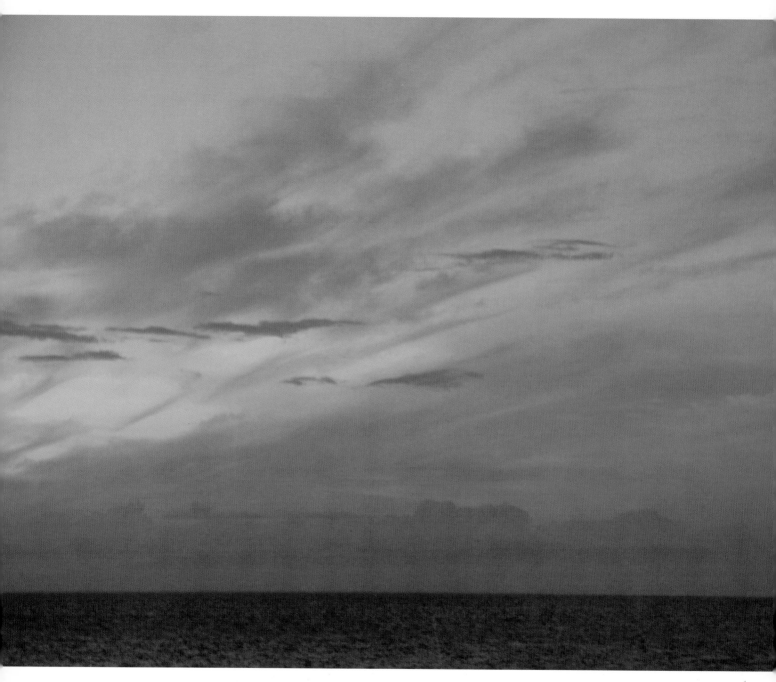

Fiji

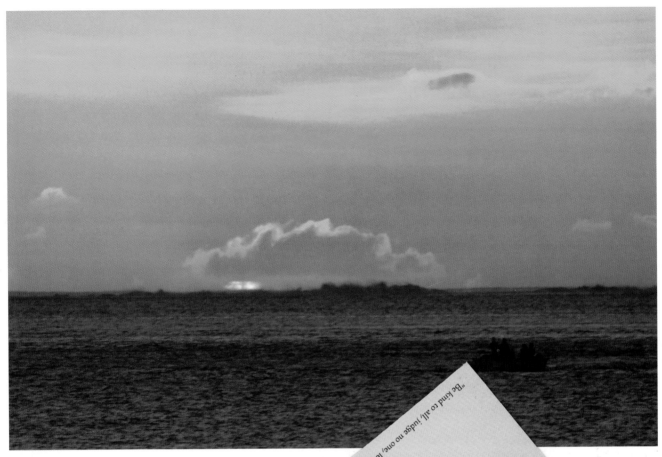

Tahaa, Tahiti

A GREEN WHICH NO ARTIST COULD [...] A GREEN OF WHICH NEITHER THE VERY TINTS [...] THE MOST LIPID SEA COULD EVER PRODUCE T[...] ARADISE, IT CANNOT BE BUT OF THIS SHADE, WHI[...] GREEN OF HOPE.

—Jules Verne
French science-fiction author
1828-1905

Lora Drasner

1-917-502-2700

lora@loradrasner.com

www.loradrasner.com

"Be kind to all, judge no one; learn from all, say Thank you." Buddhist saying

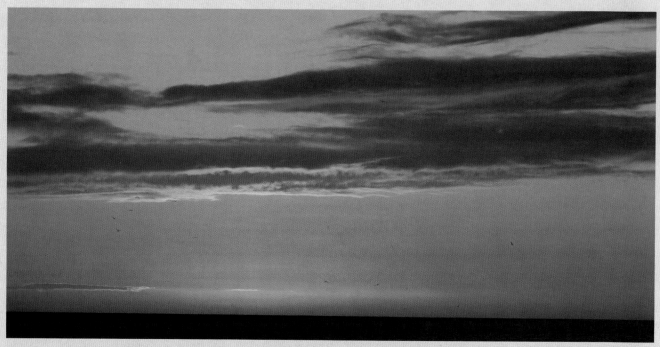

Fiji

I'VE LEARNED FROM EXPERIENCE THAT THE GREATER
PART OF OUR HAPPINESS OR MISERY DEPENDS ON OUR
DISPOSITIONS AND NOT ON OUR CIRCUMSTANCES.

—Martha Washington
First Lady of the United States
1731–1802

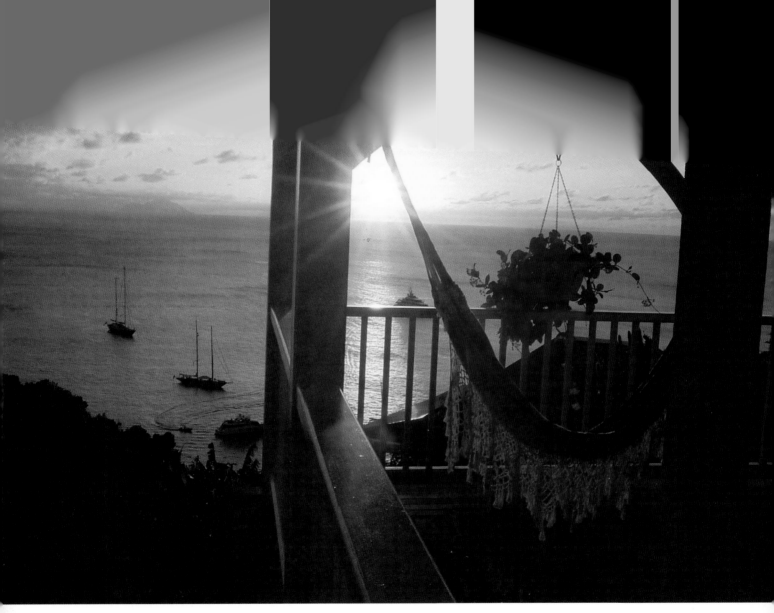

Caribbean

Happiness is not an ideal of reason but of imagination.

—IMMANUEL KANT

GERMAN PHILOSOPHER

1724–1804

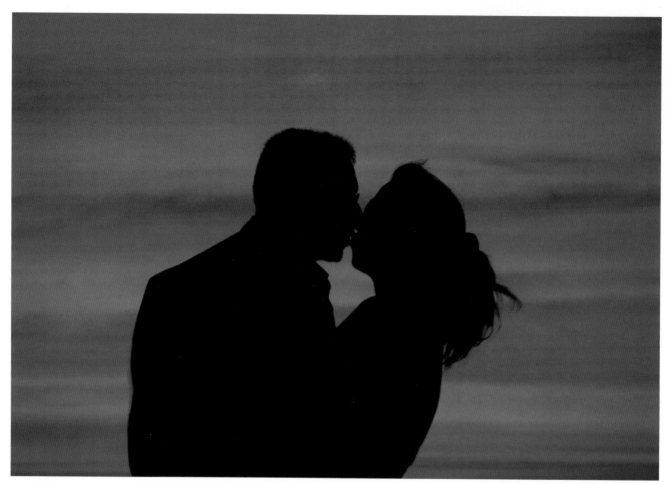

Mustique, Caribbean

Love conquers all things; let us too give in to love!

—Virgil
Roman Poet
70–19 B.C.

Mustique, Caribbean

The great essentials to happiness in this life are something to do, something to love, and something to hope for.

—Joseph Addison
English politician
1672–1719

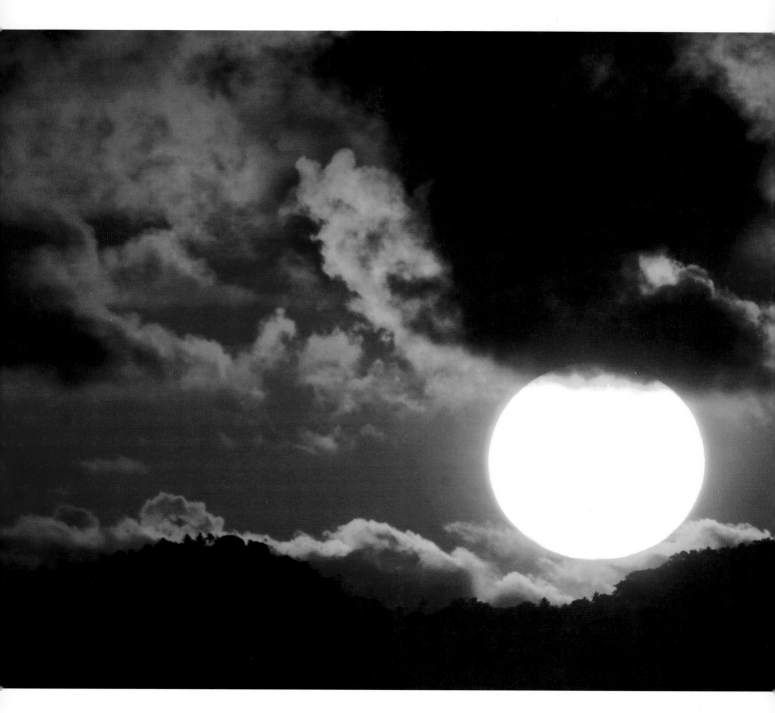

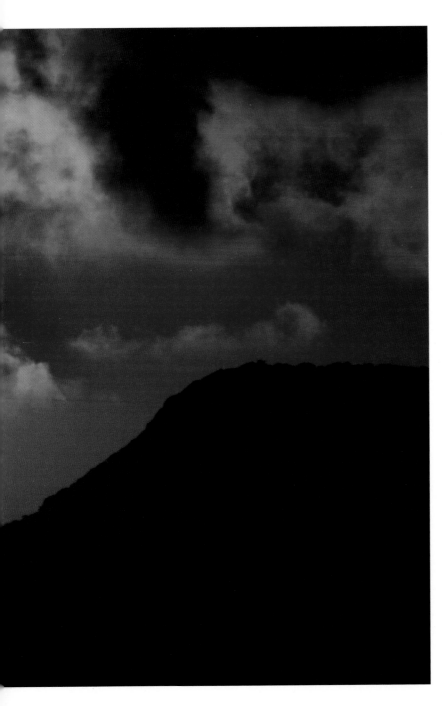

There is only one happiness in life: to love and be loved.

—George Sand
French feminist
1804–1876

Tuamotu Islands

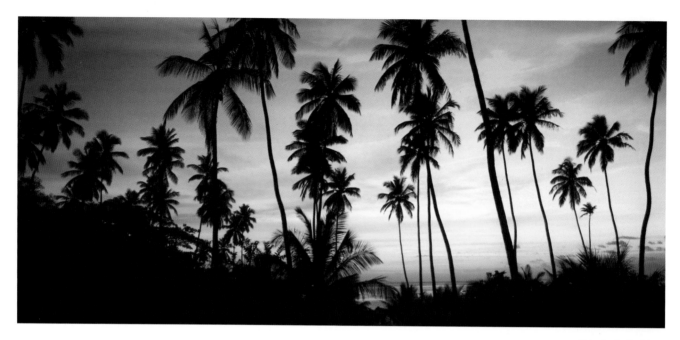

Saint Lucia, Caribbean

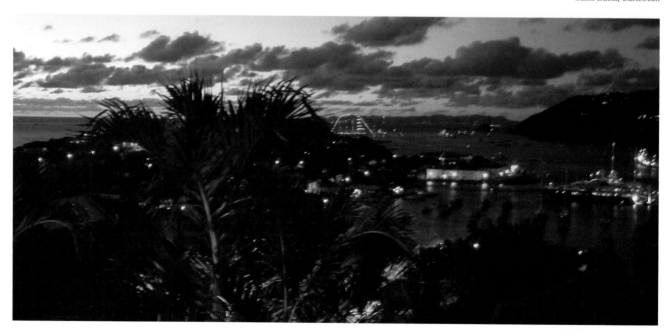

Saint Barths

THERE IS
ONLY ONE DUTY,
THAT IS
TO BE HAPPY.

—Denis Diderot
French writer
1713–1784

If you want others to be happy,
practice compassion.
If you want to be happy,
practice compassion.

—Dalai Lama
Tibetan spiritual leader
b. 1935

Do not seek to have everything that happens happen as you wish, but wish for everything to happen as it actually does happen, and your life will be serene.

—Epictetus
Greek philosopher
c.55–135

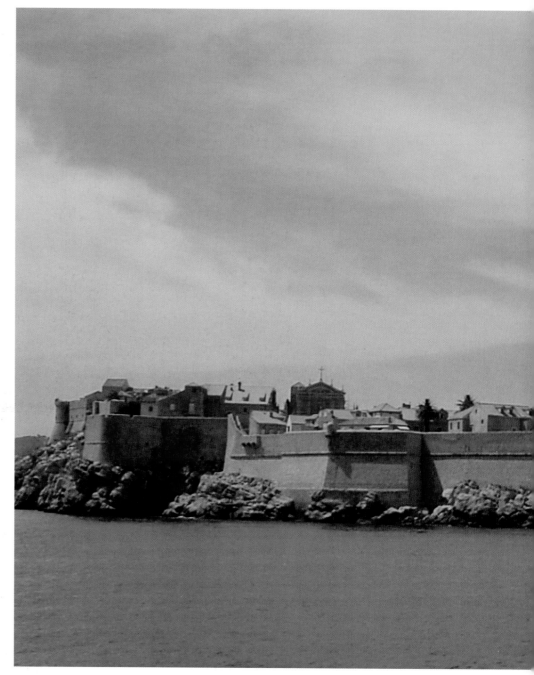

Dubrovnik, Croatia

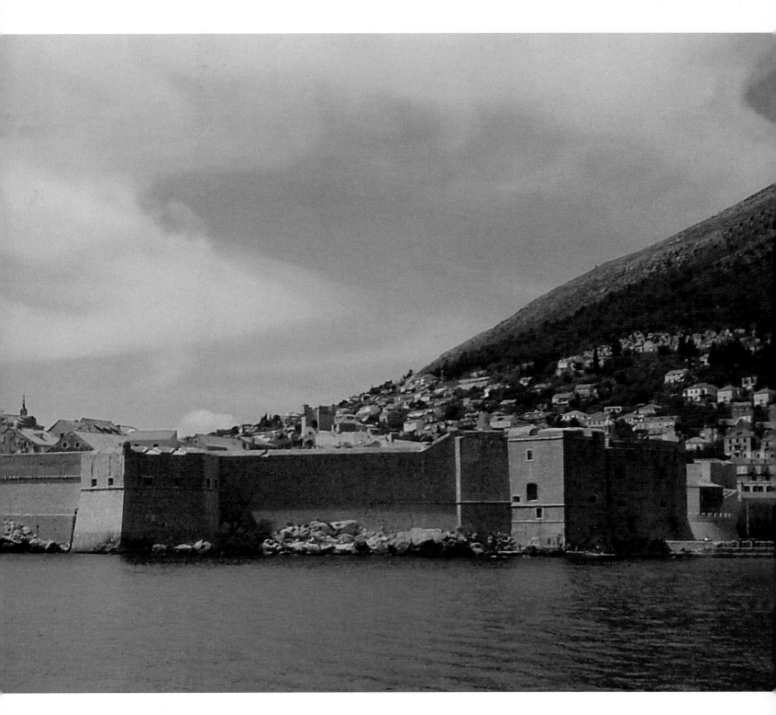

Journeys

Florida

A journey of a thousand miles begins with a single step.

—Lao-Tzu
Chinese Taoist Philosopher
c.6th century B.C.

MAKE VOYAGES!
ATTEMPT THEM!
THERE'S NOTHING ELSE.

—*Tennessee Williams*
American Playwright
1911–1983

Saint Barths

The wisest men follow their own direction.

—Euripides
Greek playwright
c.485–406 B.C.

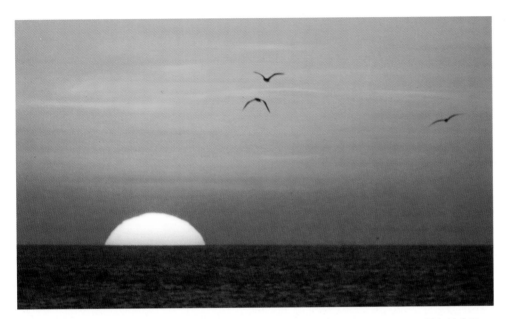

Nuku'alofa, Tonga

It isn't
that life
ashore is
distasteful
to me,
but life
at sea
is better.

—Sir Francis Drake
English privateer
1540–1596

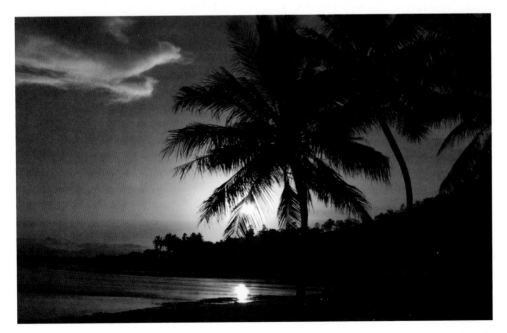

Hayman Island, Australia

85

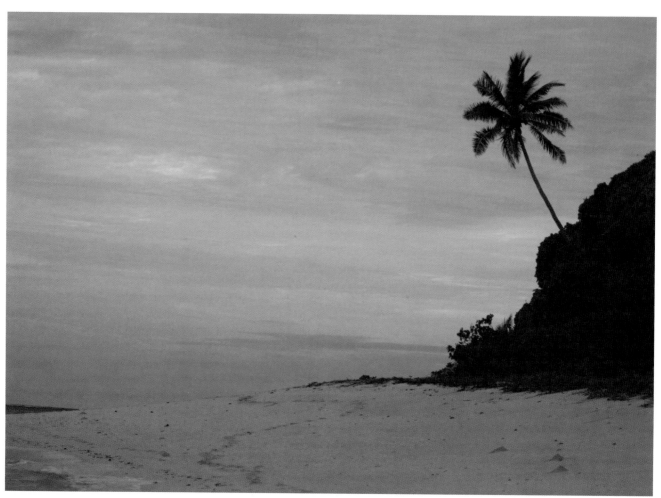

Ha'apai Island Group, Tonga

Passion above all else is a remedy against boredom.

—JOSEPH BRODSKY
RUSSIAN POET AND ESSAYIST
1940–1996

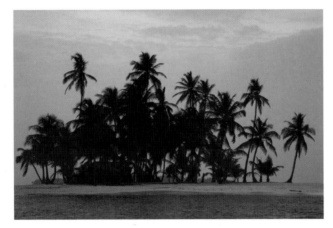

San Blas Islands

EXPERIENCE SHOWS US THAT LOVE DOES NOT
EXIST BY GAZING AT EACH OTHER BUT LOOKING
TOGETHER IN THE SAME DIRECTION.

—Antoine de Saint-Exupery
French aviator
1900–1944

Life can only be understood backwards, but it must be lived forwards.

—Soren Kierkegaard
Danish philosopher and theologian
1813–1855

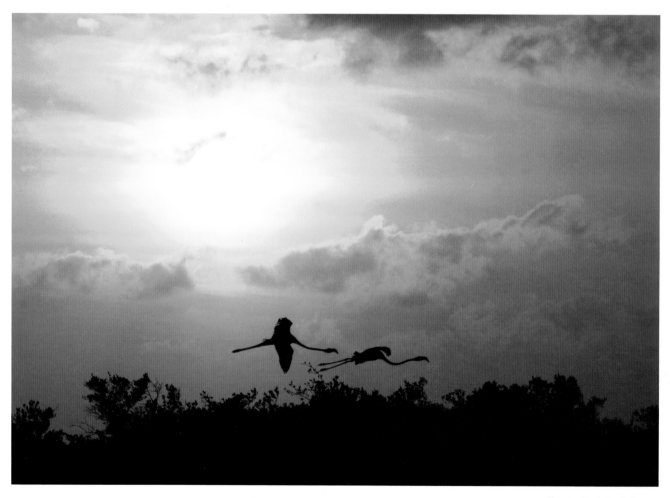

Bonaire, Netherlands Antilles

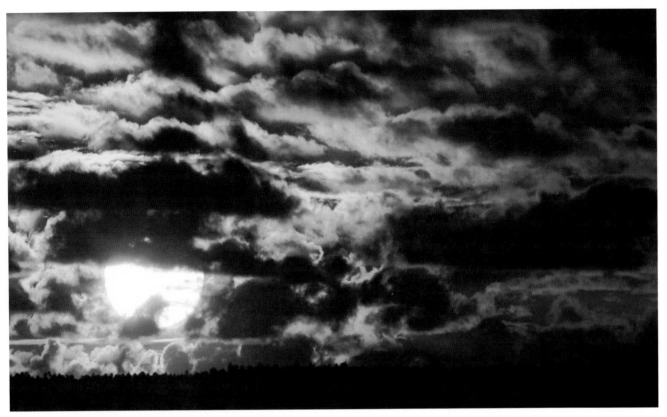

Rangiroa, Tuamotu Islands

The difficult
is what takes
a little time;
the impossible
is what takes
a little longer.

—*Fridtjof Nansen*
Norwegian explorer
1861–1930

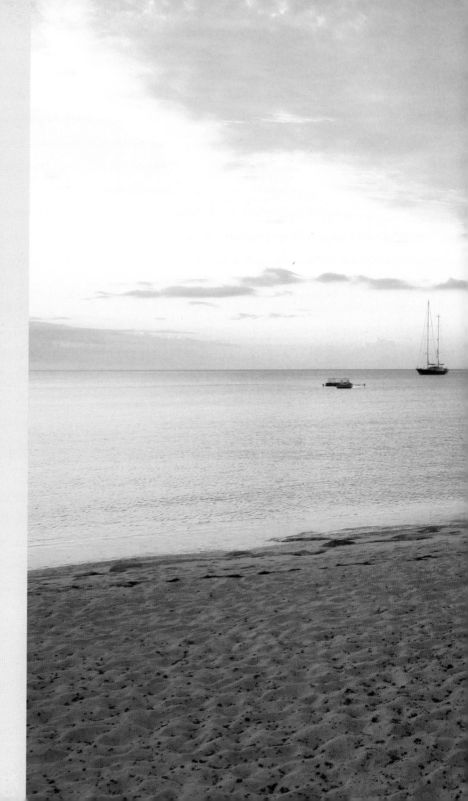

If a man be gracious and courteous to strangers, it shows he is a citizen of the world.

—Sir Francis Bacon
English philosopher and statesman
1561–1626

Dravuni, Fiji

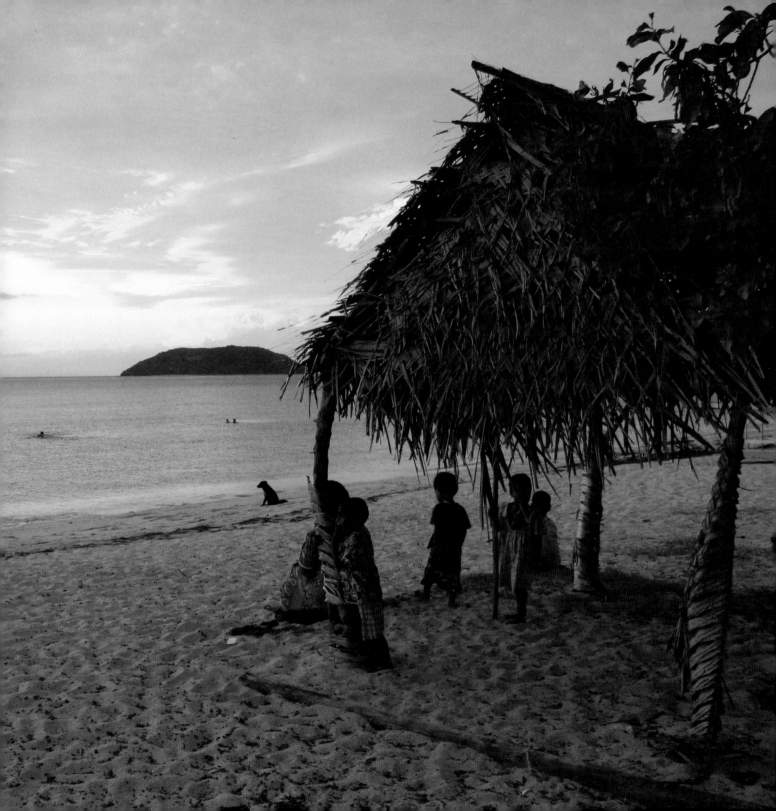

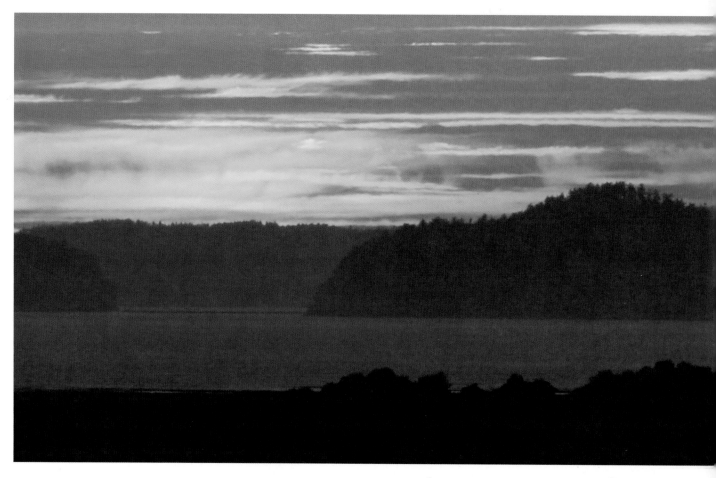

Why do people so love to wander?
I think the civilized parts of the world will
suffice for me in the future.

—*Mary Cassatt*
American painter
1844–1926

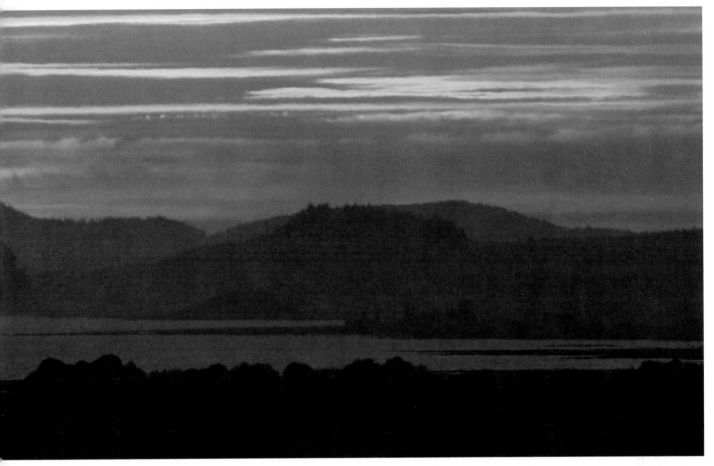

Skagit Valley, Washington

A man travels the World in
search of what he needs
and returns home to find it.

—George Moore
Irish novelist
1852–1933

While we stop to think, we often miss the opportunity.

—Publilius Syrus
Roman writer
1st century B.C.

ALL THE BEST STORIES IN THE
WORLD ARE BUT ONE STORY IN
REALITY—THE STORY OF ESCAPE.
IT IS THE ONLY THING WHICH
INTERESTS US ALL AND AT ALL
TIMES, HOW TO ESCAPE.

—*Arthur Christopher Benson*
English businessman
1826–1877

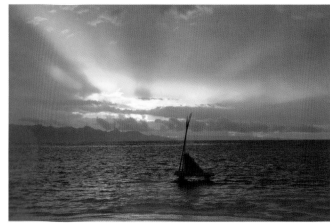

Wakaya Lagoon, Fiji

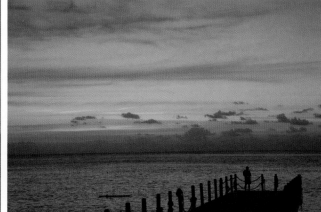

Saint Lucia, Caribbean

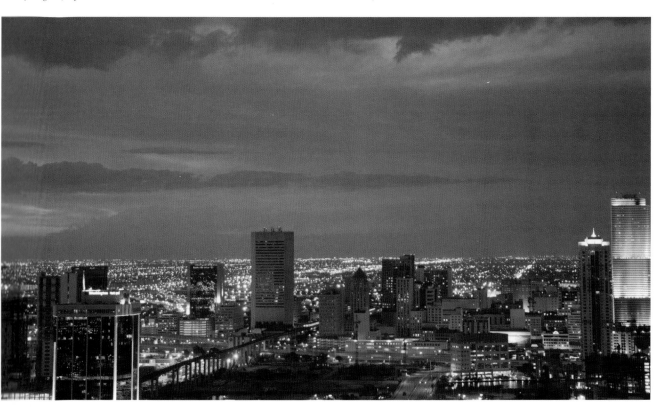

Miami, Florida

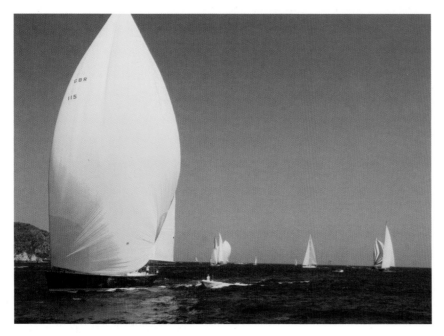

Caribbean Sea

Twenty years from now you will be more disappointed by the things you didn't do than by the ones you did do. So throw off the bowlines, sail away from the safe harbor. Catch the trade winds in your sails.

Explore. Dream. Discover.

—Mark Twain
American writer
1835–1910